A Rose By Any Other Name...

A collection of thoughts in verse.

Arunav Barua

ISBN: 978-1-4907-0511-8 (sc)
ISBN: 978-1-4907-0589-7 (e)

Trafford rev. 06/18/2013

 www.trafford.com

North America & international
toll-free: 1 888 232 4444 (USA & Canada)
phone: 250 383 6864 ◆ fax: 812 355 4082

To *Deuta*, my best friend and guide through times adverse, happy in my happiness, sad in my sorrow and a rock through my trials.

To *Ma*, who taught me to love books, to be happy in small measure at even ordinary instances and the value of human relationships.

To *Rumpi*, who is, and has been the one who made my failures seem bearable because of her being there, fighting her own battles with courage and bravado.

To *Ron*, who has so naturally adapted to being a part of the family.

And to *Duffer*, who doesn't need to be told anything except 'duffer'.

FOREWORD

Some time ago, a young boy was admitted in a critical state under my care following a traffic accident. As providence would have it, he gradually started to recover and fortunately for all of us, he made a complete recovery. As he was recuperating, my daily interaction with him gradually turned into a more personal one from a mere doctor patient relationship. I gradually discovered that there is a unique intensity of thoughts in this young man quite uncharacteristic of people of his age. A more pleasant surprise was in store for me when I discovered that the boy is a prolific composer of verses, and that too in English!! This young man was none other than Arunav.

Poetry has fascinated mankind from time immemorial and I was no exception. The lyrical flow of words in sync with one another, the covert expression of deeper thoughts of the poet.... all are esoteric to people like us who cannot compose but can only appreciate. Arunav's poetry has all that I can understand and appreciate. One day, he presented me with a book which had two of his poems were published. The words that he wrote on the presentation page touched me so much that I took it as one of my best awards of my medical career. He later presented me with a compilation of his poems and after reading them, I felt that they must find the wider readership they deserve. I constantly encouraged him to publish them. Moreover, the practitioners of this craft in English language are few and it was imperative that readers get access to them.

It is with this background that I take the immense pleasure in conveying my best wishes to Arunav on his maiden publication. May all enjoy the lyrical beauty as much as I have been doing all these days.

Dr. Navanil Barua,
Director, Neurosurgery,
G.N.R.C

Institute of Neurological Sciences, Guwahati, Assam, India

THE SOURCE OF ALL ART

If given a chance, a question would form,
 Eons of paper turned to find that elusive home . . .
Where each question is followed by its answer,
 Where bygone eras meet the present in the here.
Can such an ideal world exist?
 I will keep turning those pages and never cease . . .
A question of morality doesnot arise,
 When the quest is knowledge's Sunrise!
Beauty, and her friends, also pay a visit,
 Together on those pages they sit.
Travelling through time with words as guide,
 Hence, slowly, all questions subside,
Give me that book! Give me all books!
 Their thoughts, their feelings, let me have a look.
Seems like I am stuck again on that page,
 I see the source of art through this maze.
Can I touch your lips and silently ask you why,
 You never came back, my love was not a lie!
I keep on searching with all my heart,
 That source, the source of all art!

STARS AND A PAPER

Once, when I had been sure,
 Well, more than I am now,
 I would look at those stars up there and pause!
I would do just that . . . pause!
I would feel me and those stars, strangely one.
Somehow, that star would become all those things
 I dreamt about and all
I would love to dream about.
It is cloudy today, isn't it?
So much for stars . . .
Now I look at that blank piece of paper,
Forming words, thoughts, feelings,
That piece of paper, is it really there?
Or, like the stars, is it hiding?
Yes, it is; words, thoughts, feelings,
Everything I can make it become,
Everything I can evoke out of its being.
Now, of course, I stay my pen,
Now, I let that moment sink in,
Now, I pause again . . .
As I had with the stars,
It is cloudy today, isn't it?

SONG OF HOPE

What would you do if the time is wrong?
When you want to, but don't have a song,
What would you do when the road is dark?
Would you just walk on, and that moment mark?

Waiting, waiting for your voice to come back,
To live through these moments, though hope you lack!
Feelings portrayed in love and hate,
When today feels like just any other date!

The Sun still rises you know,
Gasping! The air you can still breathe though!
When birds and flowers don't amuse you any more,
That is when you can sing your own lore . . .

Feelings unleashed like the waters in a dam,
When you search for a light, yes, that lamp!
Light it then and see the rays of hope,
That dress of despair, now slowly disrobe . . .

You will know you have come full circle, heed,
When you find your voice and sing that need.

That song of hope . . .

A CHILDHOOD PROMISE

Promises don't fall on empty ears,
 Ether hearing what man could not.
Somewhere there is a semblance of trust;
 Somewhere promises are meant to be kept!
Towards that direction let me rest my head,
A while . . .
A while . . .
I was promised a tomorrow when I looked at those stars,
 On that tin roof, in that wooden house.
Beside green hills and a stream flowing gently by;
 The murmur of that stream making it an oath,
That promise . . .
That promise . . .
I heard it clear, that twinkle in time,
 That night the stars spoke to me;
And I lent my happy, receptive ears.
 They promised me a tomorrow,
Did they know I was a child though?
Still learning . . .
Still learning . . .

Above me, and beyond, was a universe,
Vast in size and secretive in purpose . . .
 If asked I would remind the stars now,
Promises don't fall on empty ears!
 Ether heard what man could not,
Again . . .
Again . . .

A CRUSH!

I was alone but I saw you today,
 Felt a bond to say if I may;
That even strangers sometimes meet,
 A silent tryst before actual words,
Before the actual conversation and playful mirth . . .
 A tryst time can only define as a dearth,
So let us colour this half painted picture.

Us and our meeting when eyes did watch . . .
 Let us keep that memory in a cellar,
And the lock let us latch;
 For it may escape, may fly away,
Forget about it, we might one day.
 Come the morrow, if the memory stays fresh,
We'll know we have not been rash.

I can tell tales of rousing scenes,
 That even theatre would fail to show . . .
But with a silent knowing, I surely know,
 That our tryst was etched in dreams.
Let me go back again and say if I may,
 I was alone but I saw you today.

A FIRE STOLEN

Did I tell you that tale of yore?
 How Prometheus found answers galore'
Stealing fire from the Gods was one;
 They say what's done cannot be undone.
Now it's not even an afterthought
 Yet we manage to forget the lessons taught.
Let Prometheus be, I say,
 Keep that fire burning and wait another day.

Now I see through eyes divine . . .
 The light of that fire I take as a sign.
A fire stolen from the Gods of yore
 Helps keep me warm and cook
As I sing a sad song on the distant shore . . .
 Can I ask you to spare a moment and look,
The reasons for quakes, which the Earth shook?
 Armageddon sounds so easy

I look on from the branches of the divine tree,
 Lest I forget lessons learnt from a distant past . . .
In my heart and soul, a purity I seek
 I wander on and fail to reach an answer
Yet always on the fire my thoughts ponder,
 Getting away from it all seems so easy
Yet I look on from the branches of that divine tree;
 I try and bring a balance yet unknown!

A FREE BIRD

Flying through the blue yonder,
 On that branch you silently ponder . . .
A blue world, a blue dream,
 Bird, fly, as you silently scream,
A world you can't make head or tail of
 In the ground as you silently shop,
For that worm, that morsel early.

Yet that branch just holds you now,
 'Cause you can and how,
When you feel like going into,
 That paradise of that untamed blue . . .
Let's try and make that journey again,
 What calls out to you?
A blue sky, a blue world, the word blue?

A PAGE FROM HISTORY

Sword askew, anger unleashed,
　No fear and no chance at blemish . . .
An utterance of an unearthly scream,
　As battle measures and fills to the brim.
Continues this scuffle on and anon
　Until the battle horns mark the end,
As darkness replaces and marks with her pen.

Be ye English, German or Indian,
　Standing tall at battle questions you human.
A question arises out of the blue yonder,
　Are we meant to fight and slaughter?
Cuff those hands in chains of iron bold
　Cuff those weapons in dungeons old . . .
Then maybe we might find some rest.

To history let us put this test,
　Onward Ho! And finally some rest . . .
From battles and skirmishes we heard talk of
　At such rumours the heart does scoff,
Does it mean we fight no more?
　Or is it just an illusion, and empty lore?
I end this mystery as I tear away this page from history . . .

A HEART SHAPED MIND

Put away that tear from your life . . .
 Let it rest in an unopened hive.
As you feel the journey tiring,
 Rest awhile, and find your poles.
Align them, ah! Didn't I tell you to?
 Put away that tear now.
Where would you finally feel free?

The world might seem cruel . . .
 Might put you to test,
Yet, answer my questions,
 Don't you have an iota of shame . . .
Or, is crying aloud, just an act of fun?
 Beyond these borders lies happiness untold
I say this to you, and me, you hold!

I heard you talking in your sleep
 And the answer is something . . .
Well, it's a secret I will keep.
 I finally learnt why you weep
I do understand your state of being . . .
 It is not your fault as you are kind.
Yes you are, and it's because you have,
 A heart shaped mind . . .

A JOURNEY HALF TRAVELLED

I've transversed over all corners of this land glorious,
 I have used means which many would call dubious.
I held on to one thing though;
 My heart I kept on a tight leash,
One song I kept singing; Westward Ho!!!
 'Cos every morn I see a red, rising Sun,
With Ra I travel and take as lessons from the only One.

The one called by myriad names,
 To the one we've sung many Rhymes.
A traveler, a co-journeyer, to the untamed west.
 The One travels every day marking his path
On a chariot unseen, unheard, yet best;
On wheels of fire, sometimes showing his wrath.

Like a river I silently flow;
 Dare I raise unto him, my bow?
A quiver full of arrows, I possess . . .
 Have some silent rule, I did transgress?
Ra! I wait for the answer else I let this arrow go.
His answer is a silent: Westward Ho!!!

AFTEREVENING

Is darkness a necessity for a song?
 Is it only after dark that you can dance along?
Or, maybe time is just ordinary
 A presence, just like you or me;
I try and define the noon gone by,
 Only after dark, I let it escape, my sigh!

Then I am treated to the middle ground,
 The essence of time, I find, is round;
A time of sorrow to let it pass . . .
 The light of a bright morn upon us,
Given that time, as I said is round,
 Noon follows like a faithful hound!

Then I let that question escape again,
 The quiet evening and a time of rain . . .
Before I decide to call it a day,
 I feel the call of a dance, as a ray!
I refuse to name it 'night'
 'Cause it's after bright . . .

I decide to christen it 'afterevening'.

CONTOURS

Adapt to the colour you see . . .
>Does it hold even a little semblance of me?
Love, you say?
>Mirth, I prefer . . .

How deep can a truth be . . . ?
>Can it even be measured?
The colours of truth
The contours of truth
Truth nontheless!

Let me sleep a while now . . .
Rest on this side
Of the shore!
You keep on sailing . . .
And keep that smile
Intact!!!

ECHOE

Pan, I welcome you,
 Voices all around me;
Surrounded by a world so noisy . . .
 The walk through a bamboo grove
The bird that said:
 Go back for there are eyes here.

The cross and that light
 That feather on your head . . .
The moving, flowing verses,
 Cosmic fear!
A pain in the soul.

One breaks into two . . .

A mountain, a house and a phone
 The ringing has stopped,
That garland of flowers . . .
 I see you in your splendor,
O Lord!!!

ENLIGHTENMENT

He sits beneath that wanton tree,
　　Waiting; his sight sore from emptiness . . .
Mind questing after answers
　　To questions beyond his grasp,
Beyond even his grasp, the chosen!

He knows with a silent knowing,
　　Of the one who realizes truth . . .
A truth such, that is answer giving
　　To all questions plaguing mankind.
Yes, you would be right in asking
　　How one answer; befitting all questions?

After a wait that fails to define time . . .
　　He awakens for his quest is complete.
The answer he seeks is his, heed!
The man who changeth,
　　Knowing age, sickness and death.
To him the Gods their power lent,
　　To search for, and find, Enlightenment!

HARK STRANGER

I open the door on knocking heard . . .
 A stranger waiting, on a cold night dark.
At once I become rigid, on my guard;
 And ask the man standing at my door,
"Identify yourself, be ye rich or poor
 A weary traveller or a mischief monger,
Identify, for I may quench your thirst and hunger."

He tells me a tale of his journeys;
 Over land I have not heard talk of.
He then asks me if he may rest . . .
 A night, a silent solitary night,
And if he could leave on the morn bright!

Hearing his tale, I understand his wear,
 I think to myself and his tiredness bear.
I tell myself that I would give him rest . . .
 As humane, this being my test.
When I open the door to let him in,
 That smile on his face was my reward to be seen.

HORIZON

As far as I can see;
 My border lies on that distant plane,
I try and tell you, that defines me.
 Yet all borders I dare to break,
I search beyond and beyond I take.
 A journey that breaks limits,
A true tale and not mere gimmick.

Rekindle now that candle burnt out,
 I fight myself and try to win that bout;
But the limit, ah! The horizon,
 Only as far as I can see.
So I search for a new definition.
 To myself, the quintessential me . . .
Then maybe I will journey beyond.

Candle in hand and dreaming eyes,
 Somewhere in that land, my destination lies,
Yet I fail to see it at once
 Because I am caught by my horizon,
I fail to break free, I fail to fly,
 I won't give up though, I will try,
Lose all borders in that limitless sky.

HOW LONG HAS IT BEEN MOON

The Earth a planet dry,
 You waiting in your orbit
Volcano and magma . . .
 Immeasurably hot and putrid
Ages later and the advent of us
 Man; ask the moon if you can
How long has it been moon?
 I ask as I would a boon!

Earth: Air, Water, Fire,
 The building blocks of Maya.
Talk of soul mates now;
 The moon and the Earth,
Never doth the twine tire.
 To feed a baby
As I take up this spoon
 All I ask is;
How long has it been moon?

LADY IN RED

Lady, I see your smile—
 The broken 'Hi' caught on your lips,
Pardon me when I fail to respond
 For I am not sure.

I tarry long and go out in search
 But of you I find no trace.
I await your return but fear,
 For I am not sure.

Tomorrow is another day
 I'll wait for the morning
With songs fill the air;
 Of that morn I am not sure . . .

LET IT LOOSE

The sound of a car's engine moving along,
 Time for the bard to put in his song
Of distant lands and forlorn times,
 A clap of thunder and the matching chimes;
Dare I take that step away?
 Or, maybe, depending on hope is the only way . . .

Light catches on soon enough . . .
 Revealing what was meant to be hidden,
From sight and understanding in a token.
 That tree stands tall extending a sleepy bough
Dare I touch it and see if this is real?
 A dream! A dream! A dream is what I feel . . .

The clutches of Maya and my thirsty lips
 A desire of making it whole again . . .
That broken dream; that forlorn promise,
 A dream in a dream of a dream.
I give you that promise and say this is real,
 Now would you give me my kiss so that I can feel?

MEMORY

What might happen . . .
 if the question is asked,
if the answers unmasked,
 Shudder then, for you fear.

Wasted years remain . . .
 But only as a memory,
and again, its in vain
 that you try to relive history.

Let it all come back then
 Those tears and that pain
When her face meant all . . .
 See, its not all in vain.

I question then and see-
 The answers laid bare;
In the end its all me,
 and I wont live forever . . .

O SORROW!

I embrace you in my heart
 'Cause when you chose
To be with me,
 I feel the importance of now.

I embrace you in my soul,
 For when you speak to me
I understand . . .
 That living has not been in vain.

This life is a miracle
 In itself . . .
 For joy comes too
 In a heart which can feel

Both . . .
 Sorrow and Joy.

OASIS OF LOVE

Life the desert, feelings the Sun,
 I ask for all as I ask for One.
Look at me then, and see the question;
 It's not hard but I have a lesson,
Imbibe in time an iota of pain . . .
 As upon us all feelings do rain,
Ah! This heat, this monstrosity,
 Fable or fact, I question the One.

He answers in his own eloquent way.
 Renders me speechless on that warm summer day;
Birdbrain I must be to take up this quest,
 All is said but not all in jest.
Come hither then! He calls out to me
 Your journey in this desert approaching an end.
He gives me a hint of silent knowing.
 I use up all of my life's silent training.

Then she enters my life, an angel,
 Of form human, beauty writ on her face.
I would have left this Earth without trace,
 It would all have ended in haste . . .
But the answer at last is mine,
 Love it is, the silent oasis,
In her I found it, Oh! The joy to me,
 My love I live on . . .
And now I can turn my face to the Sun.

OLD FRIEND THAT YOU ARE

A bond that we held on true,
 Through time and beyond place
In time for it to all come back,
 Let's not waste these moments in haste.
I heard beyond the sea your home
 Doth lie, too far to swim beyond Rome.
Happiness I wish you, and a cup full of joy.

As you prepare to warm your hearth;
 Remember there lies a friend in dearth.
Beyond all borders we will fly.
 Let's make this flight of friends and try
To overcome pettiness and our silly ego . . .
 I search for you, search high and low,
Yet you are beyond an ocean and away.

Let's come to an agreement then,
 You fix the time and tell me when
I can see your smiling countenance again . . .
 I see you sometimes in that blossoming flower,
And sometimes I see you in that tree,
 Is it you I heard in that song?
Oh silly! Or, is it just me???

PROGENY OF HOPE

Feelings unruffled, sword askew,
 Seeing two, of what should be one;
A losing battle in the battlefield of life.
 Somehow close to that goal, a boon,
I come again, hoping to succeed;
 In the twice as I silently strife,
There is a letter unmailed in the box.

I sow the seed of injustice again,
 In a land I dare to call mine.
I find there is a doorway between
 That yesterday gone by,
And in that today, to live, I try.
 I give it time and hope,
Tomorrow will bring its progeny,

The progeny of Hope

RAIN

How shallow can you be?
 If that smell of the fresh Earth
The fresh earth does not
 Unsettle thee . . .

Maybe extracts will do justice;
 Then go back to a time
When everything was,
 As a child should see.

Judge not the droplets
 Upon your palm:
Just look up and
 You will forever be . . .

One, with the rain
 And sing to his glory.
Don't forget to look down again
 The Earth doth you see . . .

THE SAILOR AND THE LIGHTHOUSE

A far cry echoeing away into nothingness,
Waiting . . .
His sight sore from emptiness,
Seeing . . .
His pain a witness blind'
Searching . . .
That elusive glimpse, a yearning . . .
Voyage after voyage'
Perilous, and not . . .
Journeys that even time almost 'forgot'

His eyes witness to a memory of her,
A picture; now fading, now clear.
As our sailor wakes up in seething fear
All he can persuade to give him some calm
Is that memory of an old world charm;
There on the rocks, his lighthouse dear!

A love that has seen the forever,
The sea his song and she his love,
Scaling the skies—a white dove;
A toothless smile, signs of aging
A fury within him raging,
Yet fond . . .
Yet seeking . . .
His one love true . . .
His lighthouse blue!!!

REST ASSURED

I gave you a rupee some time back,
 Never did I see its face again . . .
Are you spending it, away, my rupee?
 Or, are you like them, another hoarder . . .
Save, or spend, or maybe just to keep,
 To look at after a tiring day's labour.
You can say that you have a rupee,
 Don't you see that all I have;
Is the lack of?

The lack of that rupee you took from me . . .
 On another of those dark, dreary nights.
I find a window and keep looking out,
 To solve this riddle beyond any doubt . . .
So you have one and I lack one
 In a way that's some equality done.
For this puzzle, I fail to solve
 Let's take that rupee and cut it in half . . .

Me, the giver
 You, the possessor;
Let's end this game here,
 Let's call the shots . . .
If you ask me, that's the only way,
 To find, and fill up these dots . . .

SAMPLE OF LOVE

Overflowing with emotions untold'
 Everything stands still . . .
As I let this story unfold.
 Feelings so gentle that they escape
The plane where they are held . . .
 I fail to capture you in them.

I try and seek a new track . . .
 That might give me my life back.
Yet you fill up, yet you flow over,
 I run and then think . . .
Need I go a little slower?
 No answers forthcoming from you,
So I sit back and in silence, my eyes lower.

Then comes a passage of time so dark . . .
 I fear to tread on ground,
Feeling I would sink even on land hard;
 Should I go over all my actions,
Somehow make sounds of love newly found?
 Will you agree to take just a little . . .
A little of my love, a silent sample?

SEEMS LIKE TOMMOROW

Your thoughts in my mind,
　And that window open . . .
Just another day of its kind,
　As I take up this burden . . .
I wait for a moment,
　But think I will write anyway;
It's the same circle I see everyday.

Everyday is such a simple word,
　But the mundane dictates it so,
Pleasure is what I seek . . .
　I am, after all, a hunter meek.
By arrows in their quiver,
　And by my sword in its anvil,
I try to change things by my will.

It's been more than a year now
　I've tried but can't see how,
I've wasted my time bidding now
　In the face of a distant tomorrow.
As I pen this song of hope,
　I'll take this paper and elope.
And then finally I can say . . .
　Seems like tomorrow, today!

SUNSET (goudhuli)

Grazing, calm in their eyes . . .
 Cows beside a wanton brook.
The storks fly in formation
 In a deep orange sky.

Evening, a tired setting Sun . . .
 Beautiful hues and colours
Extend from a living sky,
 Eyes staring, trying to comprehend.

Coy now, the cows move home
 As darkness and stars replace
What for a moment was . . .
 The faint outline of a shadow.

TAKE ME AWAY

Take me away somewhere where I can find,
 Rest, peace, love and words kind,
Take me away somewhere where I can find,
 Joy, and to that glory, my heart bind . . .
Is there such a land or is this a dream?
 A Utopia of Utopias beyond this realm,
Seeking with a sword held at its helm!

Take me away somewhere where I can find;
 Justice, pride, freedom and a sky,
Where I wake up on a today
 Not mired by human corruption . . .
Where the path leads me to a clear blue destination.
 Am I the only one seeking now?
Wasn't it Arjuna who let the first arrow flow?

Let me continue this journey alone . . .
 Even though I seek a companion,
Someone to talk to after the days work,
 A friend to share with and at troubles mock.
Take me somewhere where I can find
 A mirror showing me my dreams back . . .
Or is it wrong to dream of, and seek, perfection?

TALE

Fallen . . .
Like a bough indescriptable,
On a sultry . . .
Hot . . .
Summer day,
Also rain.
I judge not for I'm not God,
Nor do I let myself be judged . . .
Am in the rain,
Wet and searching;
For the answer that will take me back . . .
To my untouched childhood.
I am me . . .
Indescriptable . . .
Unknown . . .
A feeling!
Keeping my promises to myself
And yet searching on . . .
Weary traveler!!!
I tell myself
And wait for the laughter,
I will not let myself away from the
Essence pure . . .
From a song sure
From a home away . . .
Before you hurl that first stone,
Find a mirror that tells your story . . .
Only yours . . .

Am still tied to dreams and hopes
And yet, I fly free . . .
Not the nest, nor lightning flashes
Will describe my journey.
Am a weary traveler . . .
Without company . . .
Tired from the same old,
The same old . . .
Yet you search a way to me . . .
I shout!!!
I don't have the answer . . .
I am not the one.
I am a shadow fleeting away . . .
Towards the light,
Far from all prejudice
Not caring for . . .
All the hatred thrown at me,
For I am untouched . . .
Unconditional love!

TEST OF COURAGE

I set myself a horizon of gold
 To travel to and conquer, heed!
And as I set myself at this deed,
 I painted a story in letters bold
As I skipped and hopped to this goal
 Is it just me, or am I growing old?
Let's see if I can reach the mark I set
 Feel the gold, the rays of a Sunset.
Beyond this region lies darkness and pain . . .
 Yet I journey on and hold the reign.

I question myself after a span of time,
 Can it be me, whose words don't even rhyme?
Yet I hold on and carry on my task
 In the rays of the Sun lie and bask.
Feeling myself close to that goal
 Staying up at night, mocking an owl.
I know I have miles to travel,
 And that throne of gold is beyond mere babble
I don't give up though, I don't rest
 I will find my horizon of gold and answer this test

THAT COME HITHER LOOK

I saw you that day . . .
 And my look went askance,
I saw invitation writ large on your face.
 On this, a certain cold winter day . . .
Your woolen top and hanging lace,
 I took a look to ask if I may,
I saw invitation and inferred as much.
 Ah! How I wish I could silently touch . . .

That beauteous face and questing eyes,
 Like an answer to some quest hidden.
Only natural that I seek out your number,
 From monotony, like arising from slumber.
Yet I journey on, firm in belief,
 That with you, a part of me, I leave.
One day I chose to make a call,
 I heard your voice and thought that was all.

No more with me, on this plane you are,
 Oh! How I miss those moments spent.
Each one I treasure, together we did spend,
'Magic' is the only word I can use here . . .
 A barking dog breaks my chain of thought,
I guess even in memory,
 Happiness is just not my lot!
All I wish is to see that come hither look again . . .

THAT JOURNEY (Deuta)

Evidence lay in wait . . .
 For justice to catch up with
The wait was long for
 Justice was forever blinded.

While she measures in her
 Measuring devices the ways
That answers can be found
 To questions not yet defined.

I see me here without you . . .
 And I realise that time
Had stood still to accommodate
 That fleeting ounce of glory past.

THE BEAST IN US ALL

Questions myriad; is anger the key?
 I raise my head and yet fail to see:
The eyes lie, the head prepares a tryst
 With himself, beyond even ether.
The one in us all, call him the beast . . .
 How shallow yet seeking his feathers.

Down below where his heart doth see,
 Scenes of anger, degradation and pain
Brought unto us by our own hand.
 Try to, and if you can, capture all land,
Beyond this dusk lies a bright morrow . . .
 As we open our eyes to a better tomorrow.

Capture all land; did I say now?
 Even then what do we find . . .
Isn't it the entire 'Gondwana' mind?
 Perchance a name you give,
To nations you capture, buy, or tame . . .
 For I see no end to this mindless game!

THE COLOUR BLUE

I see the blue you see,
 It's the same, the difference just me.
My mind wanders on that spot
 I left on that snowy cloud.
I mark my blue and show it to you,
 You say it's yours but I feel a doubt.
How can your spot be the spot I mark?

I tell you that the sky is vast.
 I laugh when you catch up fast
How can your spot be my spot?
 Isn't the sky vast . . .
Well, it's not just a dot!!!
 I draw a full stop on this premise
When you try to take away my blue.

Yet you fight, you struggle to hold,
 On that night I show you I was right.
I ask you to show me your spot that night,
 And you fail 'cos it's dark outside . . .
You show me a star, 'but that's my star', I say,
 Cos I have it in my mind,
I see you laugh and have your say;
 "You can take my blue away."

THE ESCAPE

Is it from nothingness the advent of me?
 I question on and the answers not see.
Yet I feel the hint given in dreams,
 As the rays of a distant star beams;
Upon me and upon this tale I tell . . .
If not from nothing my question is meant,
Can I say the me is eternal?

A little scary the thought is . . .
 How can I fail to answer this?
Let's try and build another pyramid,
 Into space let us throw this thought . . .
What were you built for?
 If no questions you answer . . .
What riddle were you meant to unravel?

Into space as I threw this question,
 It struck the pyramid and echoed back . . .
I heard the soft spoken spell then;
 This life is a blessing, treat it so,
Do I hear laughter, do you mock me do?
 Finally upon my throne I sit,
It rests on top of that timeless pyramid.

THE HEARING AID

"Eh!" That's you again, a noise you make,
 "Eh!" I know that voice,
It's yours as you silently speak.
 You fail to make words,
Or construct syllables in herds,
 But that sound makes itself heard . . .
Over the din of an unspoken word.

Then I make out words with my lips,
 So you can see words forming at the tips,
You need to see sound,
 As much as you try to hear . . .
This burden as you silently bear.
 The aid you use to try and give voice
To all this meaningless chatter . . .

The hearing aid that connects you to me.

THE LOG ON THE ROOF

When it pours and rains;
And I welcome that clap
of distant thunder . . .
pitter-patter, pitter-pat,
that noise on my tin roof sat . . .

Fierce winds and rainfall later
Woe is me! For I fear this weather
I climb the pear tree adjoining
Let the branch drop me hoping . . .
to cure any damage done
Ah! but my tin roof is a strong one

Or is it that log?
that log fallen on the roof . . .
that log holding it down,
As would a horse with the hoof?
Thank you log, thank you, I wonder
"Stay on my roof
every time it should thunder!"

THE LOGIC FOR A HORSESHOE

He tried walking on tar,
A gallop too . . .
A canter maybe,
And he missed, our horse,
He missed the soft grass
the cushy sand
and the boulders he could avoid
In the forests of yore!

I broke him in . . .
That was not difficult.
How do I stop the tar,
the stones hurting him?

Can I use Iron?
From the Iron Age?
Aye, I will!
soften the stones and tar . . .
Make him a horseshoe
My friend, my horse true . . .

THE NEST

I use an asterix to mark the spot . . .
 All the creepers and grass you brought,
Bird that you are, in your solitary nest . . .
 Hear all! I speak on their behest.
Yet you fail, you fail the test,
 How would you when the branches, on emptiness rest?

Fly away now to bring back more . . .
 Of your attempts, let me tell this lore;
Of a bird and his mate,
 In an attempt to their love consummate,
Yet they fail for the branches rest . . .
 On emptiness they cannot build,
Though they try their best!

Yet they endeavour, they hunger on,
 To build a nest of their dreams,
Even through failure, sing their battle song,
 Sing with glory, chirping with joy,
For they believe it can be won;
 Their nest, somewhere they can finally rest.

THE QUEST

Every Quest begins with a question,
So was mine, a silent, solitary mission . . .
To find and place the nature of time.
Is it a circle perpetual, going around itself?
Other such questions on which I dwelve . . .
Time itself defies definition
Being happy in itself, lines or a circle.

Questions to which it doesn't need answers,
Be they right, be they vague.
It's like asking apples from an old rag.
Time will not tell you what it is,
Just take joy from the fact that it is . . .
Beyond explanation and all kinds of realization,
It becomes a part of you though.

As you journey from childhood to age,
Give in to that built up silent rage.
Weary traveler, who journeys with thee?
Isn't it time that we can all see!!!
A perfect companion and a silent ear;
Be it linear or a weary circle . . .
I will just put my head in a shell,
Like any common day turtle.

THE RETURN

The Sun shines through,
 Early morning blues . . .
Seems like yesterday,
 When laughing was so easy,
Mirth was unquestioned,
 Joy for granted,
Let's become again
 All as one . . .
Children, and see.

THE SEARCH . . .

I have been searching for you
Evasive as you are, thought,
Been a while now since then,
That yesterday, that promised morrow . . .
Elusive, yet tangible,
freedom, in a prison dark.

Your light leads me through
thought, evasive as you are . . .
A mirror might catch you,
A broken glass, mould your form
legends are born of you
and the many . . . morrows you promise.

Today I drove my car,
At speeds beyond imagination
to catch you, thought elusive,
yet you managed to escape . . .
yet you managed to strangle free
From my car, and its speed.

I have you cornered now
Elusive thought, and your progeny . . .
so bring me my promised thought
and its promised morrow . . .
bring me my dream of tomorrow.

THE SOUND OF ABSENCE

I heard the sound of your absence
It's a sad sound . . .
Leaving me lonely,
Leaving me forlorn . . .
Somehow things just don't click without you nearby,
Missing you is such an easy word . . .
Yet real, yet felt!
I try and become my old self . . .
I discover it's not possible without you,
I miss you and your proximity . . .
To an essence I would call mine.
It's a feeling that completes the journey,
We undertake, calling you and me . . .
I guess I will just call it us.

PASSION

Irrationality drives a passionate man;
 Tinkles of time beyond reason,
Like water waiting at the gates of a dam . . .
 Happens now, or, in any season!
Passion it is that keeps him going,
 A knowing touch, that familiar yearning.

Trying to break free from the senses,
 Yet caught up in life's story . . .
A story of tears mingling with joyous rinses,
 Are the senses real or phony?
That bird calls out to me and questions,
 Lest I forget life's silent lessons.

Then I meet her, though, in a dream;
 My senses let go of all restrain
Try as I might to curb my hunger's beam,
 I lose everything when I see her again.
Now it's silent, now it's gone;
 Passion it is that left me alone.

THE WAIT

The temple waits . . .
 A thousand year long wait,
Once 'she' stood proud,
 And man, he marveled at her pride.

Then came the rains, the storms, the floods, the winds,
 The first brick to fall was quickly replaced,
But the torrents that followed
 Were irreplaceable . . .

Only tourists visit her now,
 Footwear now allowed.
While 'she' waits . . .
 For the rains, the floods, the storms, the winds,
For the last brick to fall,
 For freedom from her past and her pride,
For Moksh . . .

THE WALK

Walking on a cliff edge,
 Talking to emptiness whole . . .
Feelings of joy mixed,
 With fear of an unknown sorrow.

Two birds move together,
 Piercing the silent evening
With their chirping;
 A jump and I would fly too.

'Fly then', said a deep voice,
 'Fly and chirp as you fall'.
I smiled and the walk ended,
 With a jump, I woke up . . .

. . . Dream on.

THE WATCH

Gifted to me in a passing gesture,
 I look at you to know thy nature.
Reflected in you, my days do pass . . .
 As I search for some hidden answer
Perchance I had you before I got you,
 For you are Time, the immortal constant.

Trials galore to make you pass,
 A time of pain and then some . . .
A time to heal and yet some more'
 As I face all of life's questions
I give it time and wait . . .
 I wait for the answer.
I see you now, cut off from you,
 As you make up the two dimensions
You complete my quest in this mission . . .
 Space and time are the universal two
That make up reality,
 Yet I keep searching for you, Time . . .

THE WALL

I might draw the line you cast,
 Molten from things that seldom last;
Some bricks and stones make up your form
 I talk of you, thinking this the norm.
Good fences make good neighbors?
Utter rubbish!!!
I say, break down all pretences.
 Mired from days packed in History's cell . . .
I free you now in this tale I tell.
 I have seen you through the ages,
Trying to tell us what tried many sages.
 You stand tall, and Oh! So forlorn . . .
Beyond man's grasp of the known and unknown.
A semblance of calm . . .
History has held you close to her bosom,
 As you play a role unquestioned by reason.
Thoughts escape and form images,
 Can I have the answer now please?
Is that mirth I hear? Laughter, do?
 If walls could speak I would give ear . . .
For your tale, I surely want to hear!

MOONLIGHT

Distant, I questioned not your distance . . .
 Except now, when life has brought this instance,
I wait and see my life gone by . . .
 You always were there in some hidden corner,
Could you come and lend an ear?
 Questions myriad as I try and hear,
Silver orb of the night sky,
 Could we get to know each other?
By and by . . .
 Cognition is what I strive for
My loneliness calls out,
 As would to a kindred soul . . .
You stand distant and O so clear,
 I could feel that dream again if only
I could hear . . .
 Conversation with the moon?
I am going mad, or maybe it is
 Just such a night . . .
Let us sit down at my hearth,
 Can I meet you on this Earth?
That music playing is my longing for
You,
Call it love, then the truest of the true . . .

A LETTER TO MY PEAR TREE

I search the strings of my memory,
 You play a role unquestioned by me.
Only fitting that I should think of you again,
 I still remember waiting, almost in pain;
Those fun filled evenings, witness of time,
 That tree house we built, something I could call mine . . .
Your branches were sturdy,
Your roots strong . . .
 And today when I look at mine,
I see that I was so wrong.

Did I ever tell you, I hated the autumn?
 Hated to see you bare in the leaf storm.
Did you feel the winter's biting cold?
 Ah! I was young and dreamt would never grow old.
Waiting for school to end, the bell to ring,
 I had written a song for you,
One I would never sing!
 We were brothers, though I never had one,
Sometimes I wish time could come undone.
 Then would come spring, as I waited with bated breath . . .

With it your fruits!
Pear upon pear I would gorge on everyday,
 Sweet and something untouched were they . . .

THE CIGARETTE

As the smoke cleared . . .
 I realised that the skies were crying,
Letting forth such a torrent
 Of grief and sorrow . . .
As is wont to be seen when a dear one departs!

Below, the farmer rejoices . . .
 Heaven's grief would feed him and his wife,
Keep them warm this winter.
 The trees dance in ecstasy,
For they grow closer to the sky they so want to touch.

The dry earth welcomes . . .
 For its wounds would be healed,
make it whole again.

What then make the heavens cry?
 Maybe it cries for us . . .
For the farmer,
Because . . .
This winter his blanket would be
Blown away by the winds.
 For the trees, because . . .
Their journey towards the heavens is futile,
 They would be struck down by lightning.
For the Earth . . .
For its wounds would be opened up again
 And seeds planted in the cuts.
Maybe it is crying for me,
For the smoke has now cleared . . .

THE LOVEBIRD . . .

There is a bird caught in a cage,
 He had been free bereft a few days,
Now though, the cage is all he has . . .
 He wears it proudly as an ungiven badge.
Days pass in silent solitude . . .
 Waiting for his mate, hoping this is a prelude,
To happier times and distant flights
 To spend with his love, those silent nights,
For he is a lovebird you see . . .
 With his love he was meant to be.
Time claimed her, claimed her away,
 Now its painful, but waiting another day . . .
He gets his food and water, yes he does,
 Seeds to munch on and to quench his thirst,
Yet, lovebird that he is, he waits for his mate;
 Hoping she would come one day, and he could relate . . .

Those days and nights he had been waiting,
Those unmailed letters he had been writing . . .

A ROSE BY ANY OTHER NAME . . .

I look out and feel a numbing gratitude
 That I have you . . .
If I call you my own, would it be termed rude?
 Fallen, a new world opens up as I see, I do.

There's a name people have given you . . .
 I am not much for names,
And truth be told I would still see pleasant dreams,
 Because of, and, for you, ah! That's true.

Every morn I look out at that tree,
 People passing and voices over there;
The day passes in your company,
 Even without voices, conversations rare!

Didn't I say people have named you though?
Yes, yes, they call you a 'window'.

PAIN

Pen in hand, thoughts of tomorrow;
Justice denied and hope departed,
Feelings true, yet an iota of sorrow
A warm blanket and into the night I tread . . .

Dreams of passion and sadness,
Waiting, waiting for you to show
A path leading away from this darkness
Tears behind, along with me I tow.

Darkness recedes to be replaced by light
Ah! Another morn to call mine.
Lonely, what I would give for a sight!
This heart has been taken, wholly thine.

Night again and I call out your name . . .
Hoping this the end to this painful game.

THE WE IN US

There is a world between us,
　　The you and the me are easy . . .
It's like travelling in a crowded bus;
　　Eyes meeting, and nothing but each other we see.

Or, should I say it's like the rain?
　　The droplets falling on bare skin,
The effect on two different people, yet akin!
　　Maybe extracts would do justice 'cos feelings drain . . .

Or, should I compare it to drunken stupor?
　　World hazy and talk slurred,
Just us and the same, says this sleepy lore;
　　It's what causes us pain, yes, hurt!

Let tomorrow dawn upon us a morning,
Where 'we' becomes 'us' and love we bring.

A PASSAGE BACK HOME

Unwritten, verse of an epic untold,
 Yet felt, though seldom in use.
Pages lost in the labyrinth of time, unfold,
 Joyous victories and the battles of life we lose!

Travel weary, my footsteps lead me nowhere,
 Still I come closer to that distant goal.
Journeys of understanding laying my heart bare;
 Home is where the heart is, I have been told!

Yet I fail to come close, I am held back,
 Carry on traveler, says a distant voice;
That voice I heard, was it myself or was it a lack
 Of things I would like doing, like making some noise?

Let me go back now, I am all alone,
Let me find my way, a passage back home!

SHE SITS FORLORN

A crowd, people everywhere,
 Alone in the melee, poise,
She sits alone yet beyond compare,
 Is it her choosing or even choice?

My eyes keep searching for a glimpse,
 She strikes me as someone strong yet weak;
Then a rare smile on her face beams
 A rarity, of heaven I got a peek!

A question strikes me out of the blue,
 What makes her choose to be alone?
Is it grief, feelings undefined and true?
 Something marks her apart in that crowded dome.

I decide to walk up to her and ask
Ah! I fear it's beyond me, this task!

SILENCE

If this is truth, so be it,
If this is the goal, let it be.
 This deep dark silence . . .
This enlightening bright silence . . .
 This silence . . .
This uncommonly loud silence . . .
 This silence . . .
Am I alone here, in this crowd
 Or is my loneliness forced?
 Somewhere, somehow.

It touches me now,
 That distant chord;
 It does again,
That childhood memory
 Ah! It is time now
The present bites me as
 I wake up.

 I continue my wait
To revert back to share
 My silence . . .

ALL AS ONE

Deep down lies a secret of yore,
 Something very real and then some more:
 Life still holds you close to her bosom,
 Makes you feel you are finally home.
There are secrets we all keep,
 Even from ourselves, when we silently weep.
Wounds carried on through memory, in time,
 Wounds forming an unending line . . .

A line that leads nowhere,
 A line you can't cross 'cos you don't dare!
Me, I have had my share of pain,
 The same all of us are, still excuses lame.
Cannot we try to be one, finally someday?
 Let the Sun shine and then make hay . . .
What stops us from coming together?
 All as one, don't you see its painful here?

WISHES

Remember that promise, those words?
 Though it is behind us now,
Time has taken its toll, and how!
 I sometimes think of it and smile . . .
Wish I could hold on to that for a while.
 To that thought, that promise;
To that moment, ah! Wishes these!
 I close my eyes and see your lips,
Those words forming at the tips . . .
 I manage to return a smile as a tease.
That clasping of hands a little later,
 You coming close, your head on my shoulder
Even then I felt an absence,
 A thought of losing you making me lose all sense.
The sad truth is we are no longer together
 On this plane, in this time, in the here . . .
All I want to do is take you back and ask,
 Remember that promise, those words?

A LIVING TREE

Eerie, cool, a gentle wind,
 Ah! Must have been raining;
I was asleep, so no real hint.
 My subconscious still needs some training,
To catch on to things happening in sleep,
To catch on to reality, however deep!

Maybe 'Zen' would train me,
 Or, maybe, the answer lies in faith . . .
Romanticism now, let me enjoy that tree,
 Its leaves green, some answer it whispereth . . .
Did it feel the rain, or was it sleeping,
Do trees awaken and hear drums beating?

Random thoughts on an April evening,
 The sign is there for all to see,
I do the math, yet no answer deriving,
 When I sleep, am I still me?
Let's ask that yonder tree again;
Now, before it decides not to awaken!

THE JOURNEY TO FIND MYSELF

A journey lived, relived and more;
It is usually the mornings,
The mornings that bring us ashore . . .
Looking back at the sea and a yearning
To climb aboard again
To sail away to some land foreign.

Spring, and her beauty marks my day,
Flowers blooming and joy all around.
If given a chance, I would like to say,
My ship has sailed, is now aground,
Seasons change, as do people,
I have to live with me and my joy triple.

You just came to mind,
'I miss you' is such a cliché.
Give me your sight, please be kind . . .
I am grounded now and have found my niche,
Look at all the travelling I did,
To find the answer is me, the seed!

SERVE THE LOVE

Suddenly, a passage opens up . . .
 All I did was give a thought,
The journey till then, a little rough!
 Must've been something, surely not for naught,
That bright passage with corridors of gold,
That music playing sounds a little cold.

But ah! What a passage, a dream,
 Taking me away somewhere,
Somewhere where all is green!
 To look at that beauty I almost don't dare,
Green hills, green grass, green hills,
A river, some millers and their mills.

Thank you, wherever you are in time,
 In whatever cosmic plane, wherever,
As I sit down on my table to dine,
 I thank thee for bringing joy forever
In a heart searching for love,
Give me a chance, I would serve!

THE SLEEPING SCULPTURE

That stone sculpture has caught my sight,
　　Emotions aroused like the sea in tide . . .
That perfect nose, those eyes warm,
　　Lifeless, yet living, a silent charm!
Your creator must have had the master's touch,
　　Your image slowly locked with a latch.

My eyes keep going back, searching you out,
　　Is today any different? In wonder I sought.
What then draws me to you, even at home?
　　You are, but made out of lifeless stone . . .
The effigy silently whispers in my ears,
　　Stones have life for he who hears.

Struck aback, I try to hear again,
　　Wondering if such it is with all men!
No wonder that you form a Buddha sure,
　　Sitting silently in the Lotus posture.
Having witnessed time unraveling,
　　Many find you only after much travelling.

Someone said it well about your form,
That 'He' sleeps in the mineral kingdom!

ODE TO A KITCHEN SWORD . . .

Its wrath merciless, its anger great,
where is your blood now,
Sword with your rusting blade?
Ah! To unsheathe your fury shallow . . .
To strike, decapitate, cut and hurt,
to maim, cripple and to draw blood.

Eons have failed to do justice
to your angelic movements . . .
that before you strike, you gently tease,
I draw strength from you blade,
As in the river of life, I gently wade . . .

In my hands you gave me great strength
of rulers and kings of a great land,
I fail to draw blood but lets do the math . . .
have you saved more than killed the ones in wrath?
Sword shining, sword sublime, sword of a lost time,
I hold you now, but is this power mine?

I think I will use you in my kitchen,
Cut up some onions and maybe a potato or two . . .
Will you serve me then, even with my clumsy hand?
That's poetic justice, to use a sword to cut vegetables, I do . . .
Lets together journey again and try and feed this hungry man.

AN IMAGINED CONVERSATION ON THINKING WITH THE HEART

Myriad expressions and years later,
Rich in experience, minus all glitter;
A sudden realization, a question verily!
How do we think, form thoughts suddenly?
Then we go into a long discourse,
You say, let thoughts just take their course . . .
Then we talk about how the brain
Sends signals, and thoughts we gain,
This seems to be the answer we were . . .
Searching for, so let's leave it there.
Then some unknown signal puts a question,
How are hope, pity, joy, love done?
Signals from the brain,
Signals somehow don't complete this picture, again!
Then our conversation enters a new dimension,
We decide to leave aside all pretension . . .
Our conversation makes us happy, but that's another thought!
Feelings give rise to emotions, giving us thoughts,
Where do feelings originate, take birth?
Why, its here in our very heart!
Let's just call that thinking with the heart.

SOMEBODY

. . . and I watched him perish,
He, who had been so strong and sure,
Now reduced to being a mortal
Realising now that he was too . . .
As his father had been . . .

The leaves speak a different tale,
For winter is always succeeded by spring
The winds of Autumn fail to stop
Their reincarnation in spring
The leaves speak of promise, of hope.

They realise their strength
As he had his and he looks unto them
Now for strength
For the winds have weakened his spirits.

The room he lies in speaks of man's vain attempts
To shelter himself against the Autumn wind
And now he sees himself,
In a new light . . .
Bestowed upon him by the leaves,
On that pear tree outside.

He watches the journey of the leaf,
Torn away from its mother,
Flutter in the wind,
Journeying in different directions,
Unaware that the ground awaits it.

He closes his eyes,
His spirits desert him.
A new leaf has taken the place
Of the one so cruelly torn away
From the branch on its mother.

Now the winds blow vainly,
For they know . . .
Spring is round the corner
And 'she' has to recede
To the ground,
As the fallen leaf had!